MW00776842

Learn Flower Painting
Quickly

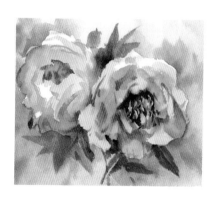

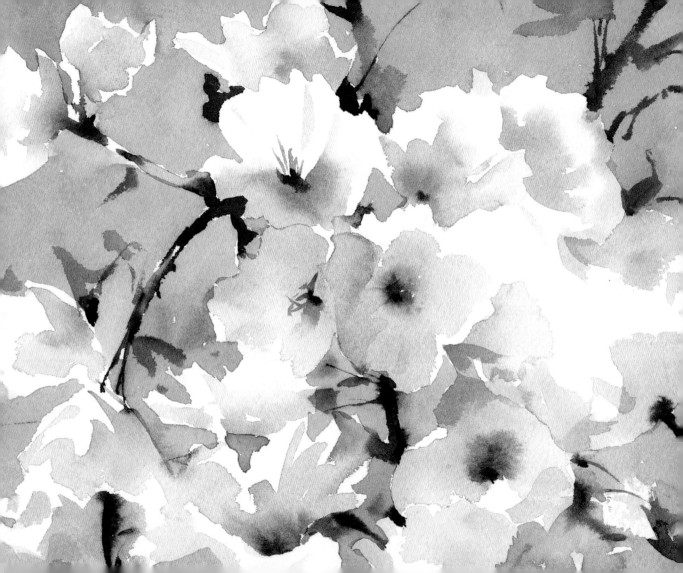

Learn Flower Painting
Quickly

Trevor Waugh

BATSFORD

First published in the United Kingdom in 2019 by
Batsford
43 Great Ormond Street
London
WC1N 3HZ

An imprint of Pavilion Books Company Ltd

ISBN 978-1-84994-522-6

A CIP catalogue record for this book is available from the
British Library.

10 9 8 7 6 5 4 3 2 1

Reproduction by Rival Colour Ltd, UK
Printed and bound by 1010 Printing International Ltd,
China

This book can be ordered direct from the publisher at
www.pavilionbooks.com

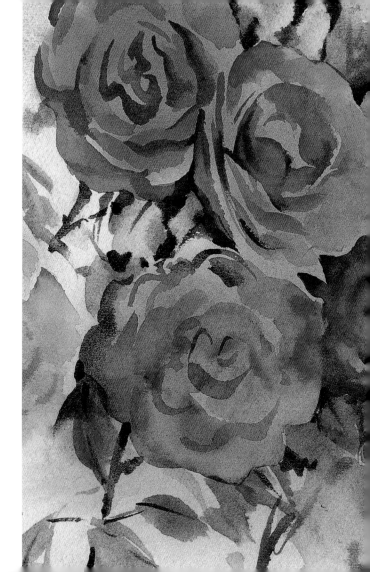

Contents

Introduction

It seems to me that watercolour and the subject of flowers in a painting were always meant for one another; the translucency and clarity of this medium reveal some of nature's brightest and most colourful jewels in a way that is hard to match. However, the mercurial nature of watercolour and the way it behaves can sometimes lead to difficulties, so read this little book thoroughly because it contains ways to avoid these as well as instructions for more creative results. I hope it will lead you on to the next step in your watercolour flower painting.

▷ **Daisy Days**
The white of the paper has been used here to capture the daisies, throwing them into relief from the surrounding darker tones of the flowers and foliage.

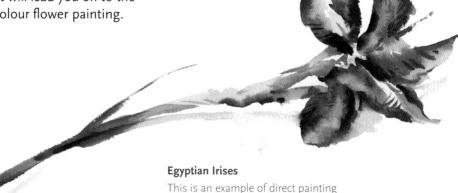

Egyptian Irises
This is an example of direct painting from the pages of my sketchbook.

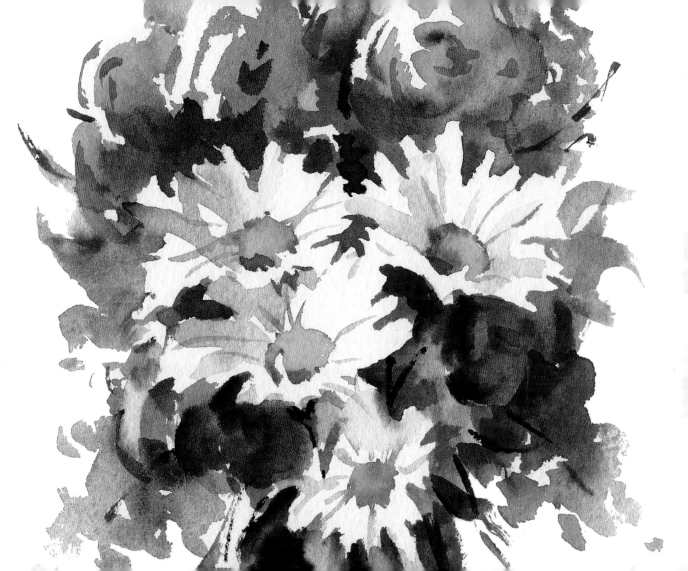

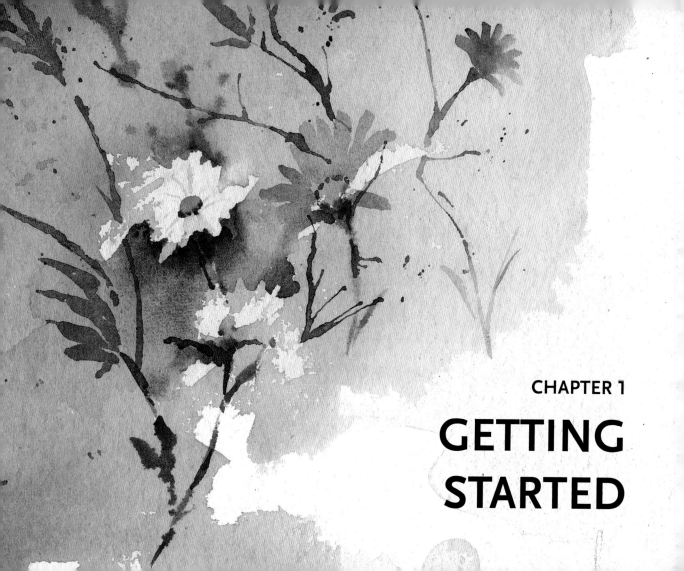

CHAPTER 1

GETTING
STARTED

Materials and equipment

A lot can be achieved with very little in watercolour, so avoid cluttering yourself up with too many materials – the essentials are all that is required. Always buy artist-quality products, since cheaper materials give inferior results and aren't as pleasurable to use. A little drop of artists' colour goes a long way, as the paints are more concentrated and don't contain any extenders, giving them a purer and more luminous look. As well as paints, brushes and paper, you will also need a soft cloth for mopping up and, of course, a large container of water.

Paints

To start with, have at least two sets of primary colours – red, blue and yellow – in your kit. Expand your colours as you go along and add another set of primaries as your confidence grows. For primaries I suggest any or all of the following. Reds: Permanent Rose, Vermilion and Alizarin Crimson. Blues: Ultramarine Blue, Cobalt Blue and Cerulean Blue. Yellows: Raw Sienna, Lemon Yellow and Indian Yellow.

Brushes

It's best to use soft animal-hair brushes, as synthetic ones can damage the paper surface. A round sable mop, No. 12, would be an excellent first purchase. When you're really in the swing of things you may want to add another brush to your painting kit, for example a larger oval mop or a hake.

Paper

Always use 100% cotton rag paper. There are three main types: Rough, a heavy-toothed surface; Hot Pressed, or HP, a smooth, non-toothed surface; and Not, or Cold Pressed, a medium-toothed surface. I recommend Not paper at a weight of 300gsm (140lb).

Laying washes

Let's get started by trying some simple washes with red, yellow and blue. Mix up some red (here I used Permanent Rose), using water and colour in equal parts to make a wash. Make sure you have enough colour to cover the size of your shape. Using your large wash brush and keeping the paint on the paper liquid, like a puddle, move outwards from the centre to form a simple flower shape. Once the shape has been formed and begins to dry, avoid working into it.

△ **Permanent Rose**
Push the wash out
from the centre to
form the shape.

◁ **Ultramarine Blue**
Keep plenty of liquid
on the paper.

△ **Indian Yellow**
Try to make the wash
as flat as possible.

Variegated washes

Washes where the colours merge into one another are termed variegated washes. This practice is essential in watercolour flower painting and leads to subtle colours. For best results, allow the colours to merge naturally on the paper. Control the flow of paint with your brush and avoid overworking.

△ A variegated wash of indeterminate shapes, using Vermilion, Indian Yellow and Cobalt Blue.

△ Start in the centre with Vermilion and work outwards with the other colours, Cobalt Blue and Indian Yellow.

△ Work quickly and try to form recognizable shapes.

Merging colours

Allow your colours to merge naturally on the paper again, this time without using the brush. To encourage this type of merge, tilt the paper this way and that to increase the flow of paint. When you have finished, lay your paper flat and let the wash dry. This method is particularly useful for establishing paler blooms.

△ Wet the centre of the wash first and then work the colours outwards in a circular motion with the brush.

△ Put the colours on the paper and let them touch using a big wash brush. Tilt the paper to increase the flow from one colour to another.

Stage 1 Lay pale washes of Alizarin Crimson, Cobalt Blue and Indian Yellow individually on the paper and allow them to merge. Allow the wash to dry.

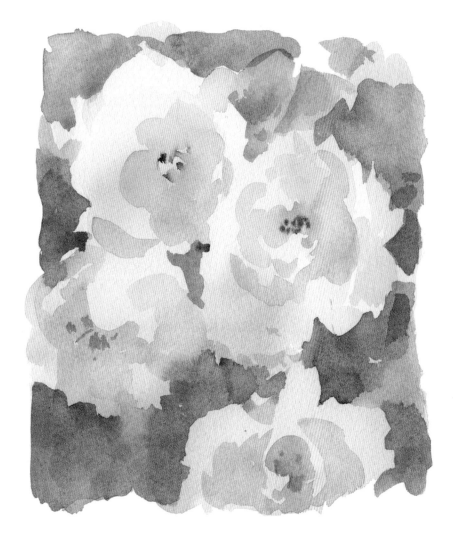

Stage 2 Using slightly darker washes of the same colours, apply to the centre areas of the flowers first. Work outwards to establish the petals and background, each time allowing the colours to blend on the paper.

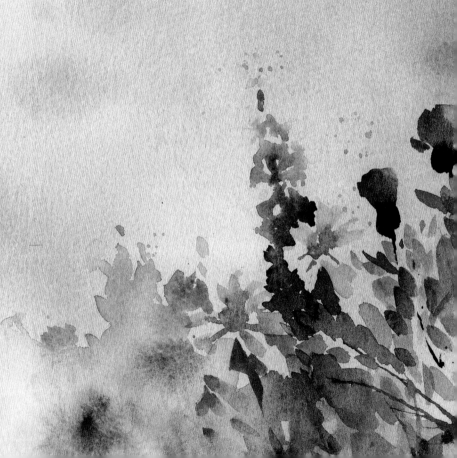

CHAPTER 2

FLOWER SHAPES

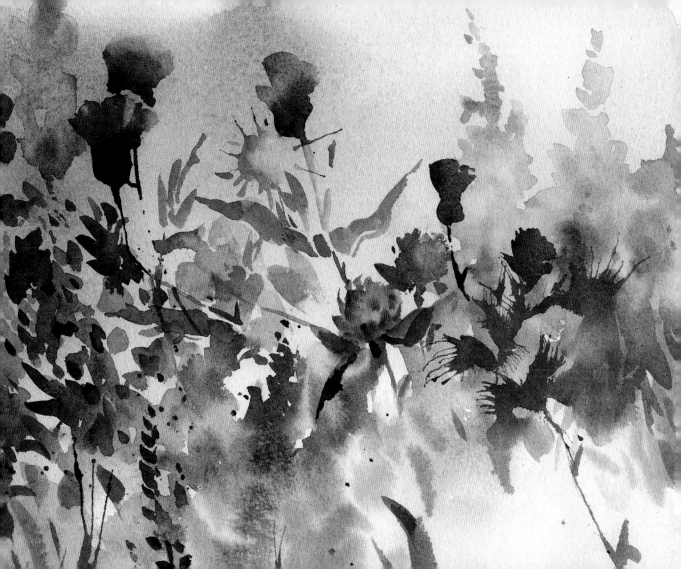

Basic shapes

Shape is a flat area or space surrounded by outlines or edges. Artists use all kinds of shapes when drawing and painting, but the three main ones are the circle, square and triangle. These geometric shapes can be used to construct a flower or leaf and the spaces in between them. This system of construction will help you to understand what's going on when observing complexities.

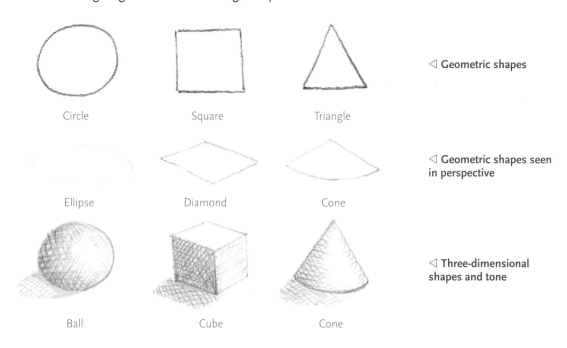

Circle Square Triangle

◁ **Geometric shapes**

Ellipse Diamond Cone

◁ **Geometric shapes seen in perspective**

Ball Cube Cone

◁ **Three-dimensional shapes and tone**

Start by drawing the three main geometric shapes the same size. Draw them freehand, without using a ruler. Correct the shapes, if need be, to perfect them. Geometric shapes look more man-made, whereas shapes in nature are naturally occurring and biomorphic.

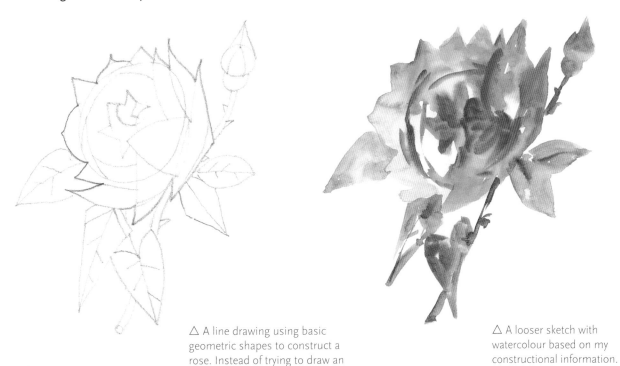

△ A line drawing using basic geometric shapes to construct a rose. Instead of trying to draw an outline I used geometry to help.

△ A looser sketch with watercolour based on my constructional information.

Constructing the flower

Observing the basic geometric shapes in flowers will help you construct them in a simple and natural way while painting. Here are some standard templates that occur in natural forms. They can be mixed and matched, for instance, a spiral rose with heart-shaped leaves.

Spiral

Cup

Heart

Wheel

△ The spiral has been modified to fit the rose.

△ Triangular sections have been taken out of the basic cup shape.

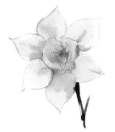

△ The heart shape has been repeated to form the flower.

△ The wheel-like shape is more obvious on a daisy.

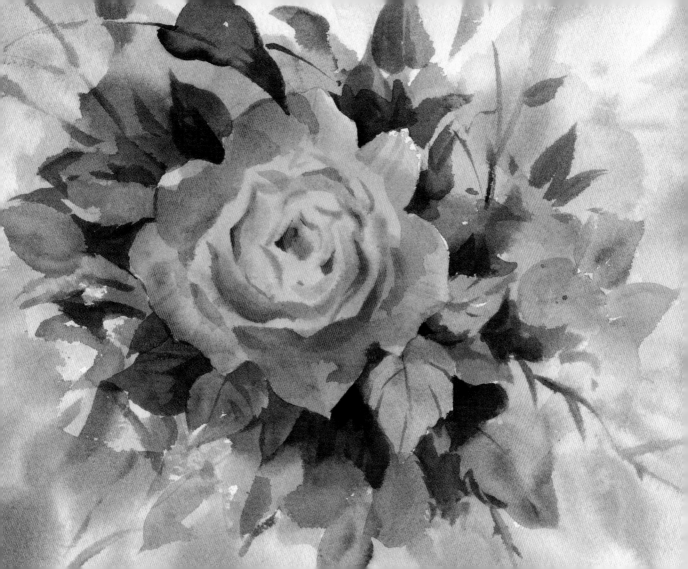

Viewing angles

It's very important to take note of the angle from which you are viewing the flower and try to convey this in your painting. For instance, are you seeing the flower from above, below or a three-quarter angle? A useful tip is to establish where the centre is and then work outwards.

◁ **Peony**, viewed from above.

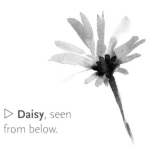

▷ **Daisy**, seen from below.

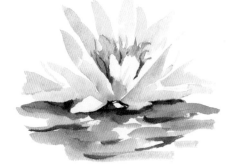

△ **Water lily**, front view.

◁ **Sunflower**, seen from a three-quarter angle.

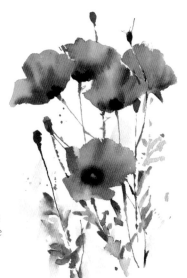

▷ **Poppies**, a group of five seen from the side and one below facing outwards.

Grouping

Flowers mainly grow in groups, overlapping each other and forming different angles. You can use your basic shapes to help you with these groupings.

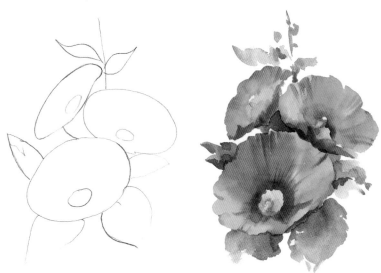

△ I used the basic ellipse shape to plot my angles and grouping for this painting of wild roses. I established the centres first to convey the slightly differing angles.

Shapes within shapes

By now you probably feel confident about fixing the outline shape of a flower with a wash, so let's take a look at the internal folds and features that form other shapes within the flower.

▷ Watch out for these internal folds and indentations. They are very revealing and quite often contain different colours to the main colour of the flower. Here the greyish shadows and pleats form an excellent foil for the yellows and browns of the centre of this lily.

△ A primrose has a dark circular centre surrounded by a star-like shape as well as curved shadows.

△ This rose has two dark triangular shapes in its centre, going in opposite directions.

△ **A rose heart** The internal shapes on a flower, although similar, are rarely identical to each other.

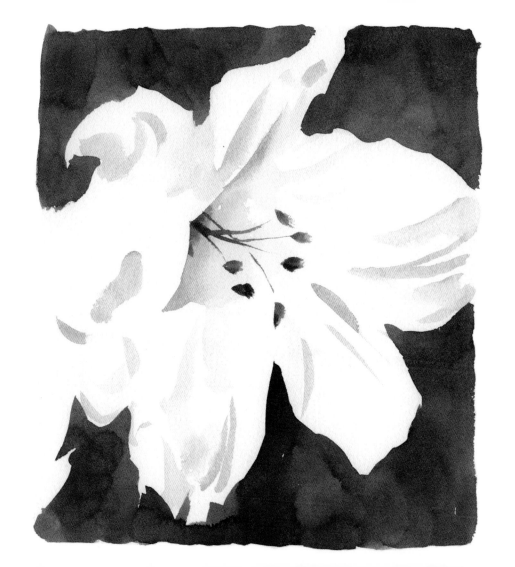

The shape of things to come

By now you should be developing ideas of how you want your flower paintings to look. Putting in plenty of practice on colour washes and shape awareness will give you the confidence to try more challenging aspects of technique.

▷ **Springtime (detail)**
Here a large grouping of daffodils shows their internal shapes and markings.

▽ **Rhododendron 'King George'**
20 × 38cm (8 × 15in)
My grouping is horizontal in this painting, allowing the large, pale blooms to drift at a slight angle downwards from left to right. The darker leaf shapes throw the flowers forward.

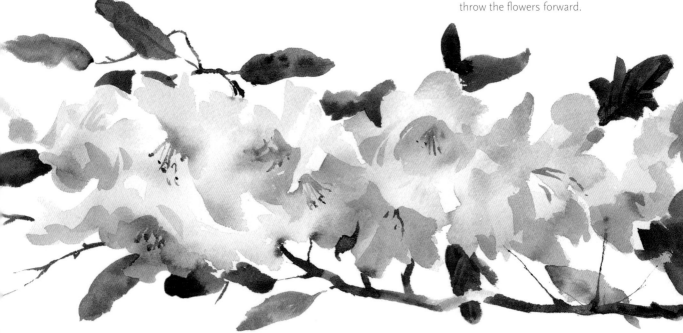

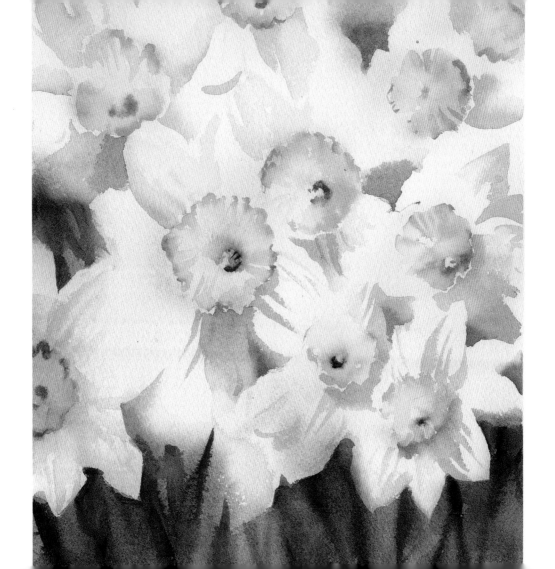

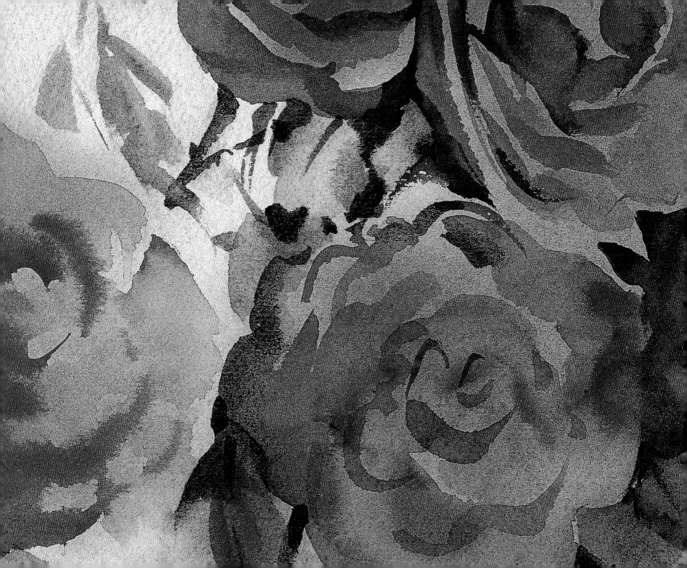

CHAPTER 3

PAINTING
BY DESIGN

Thumbnail sketches

It always makes sense to have an idea sketched out before you start – if you get a plan of action or a thumbnail sketch going, you'll know what is going to happen. Keeping the thumbnails very small will stop you getting bogged down in too many details. Good paintings have solid structures that they rest on, so let's work on the design.

▷ Upright format

△ Square format

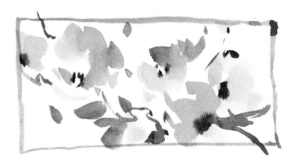

△ Letterbox format

Design

Good design is all about choices of shapes, tones and colours: where they are put and at what sizes and intervals they appear in the painting. Backgrounds can be sorted out at this stage as well. Below are some basic designs worth noting and easy to remember.

△ S-shaped design

△ Off-centre design

◁ L-shaped design

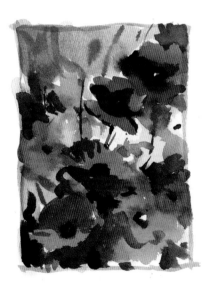

△ Diagonal design

Variety

Vary the elements of your painting as much as possible to keep things interesting, especially the sizes of the flowers. I often use the 'mummy, daddy, baby' principle when it comes to sizes. This makes natural family groups and helps with foliage arrangements.

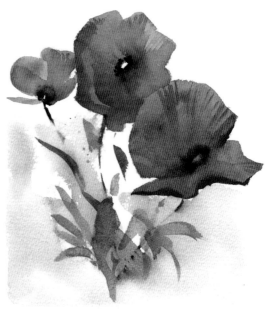

▷ **Poppy Trio**
18 × 15cm (7in × 6in)
The different sizes and shapes of the flowers can make a more interesting and simple group.

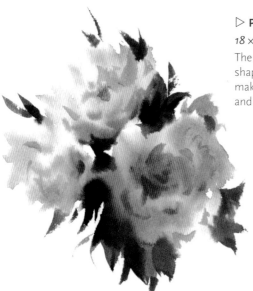

◁ **French Peonies**
18 × 16cm (7in × 6½in)
The varied pinks of the peonies stand out against a dark background of leaves.

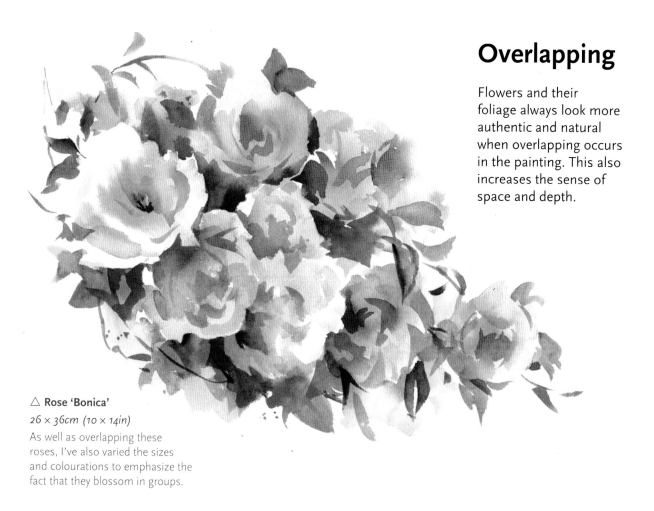

Overlapping

Flowers and their foliage always look more authentic and natural when overlapping occurs in the painting. This also increases the sense of space and depth.

△ **Rose 'Bonica'**

26 × 36cm (10 × 14in)

As well as overlapping these roses, I've also varied the sizes and colourations to emphasize the fact that they blossom in groups.

Demonstration: Painting Poppies

The diagonal design comes through very strongly in this demonstration piece in which the field poppies and their placements hinge on the diagonal axis. A sense of movement is created as a result. The main components should be established first, and the details left until the end.

Stage 1 I laid in the basic shapes over the white paper, using pale washes of Vermilion, Permanent Rose and Indian Yellow. This can be done roughly as the shapes will alter later on.

Stage 2 I worked on the inside shapes of the flowers with further washes of Vermilion, Permanent Rose and Indian Yellow. While wet, I added the dark centres with a mix of Ultramarine and Vermilion.

Stage 3 I worked into the background with large washes of Ultramarine and Indian Yellow to trap the flower shapes in a variety of different greens and blue.

▷ **Final stage** *20 × 15cm (8 × 6in)*
It's almost there except for a further
dark passage to emphasize the diagonal
and create more drama in the foliage.
Dark mixes of Ultramarine, Permanent
Rose and greens will achieve this.

Stage 4 I then started to add in more
stems and leaves, with slightly darker
mixes of the same colours.

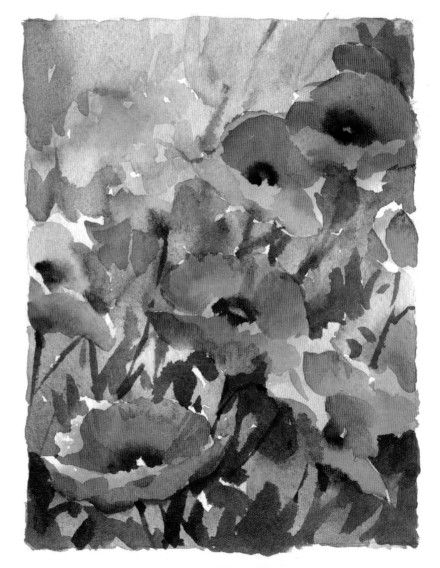

Let the water do the work

When the paper is dampened with clear water or is still damp from a previous wash, you can introduce paint with delicate strokes of the brush. This paint will spread out to form a blush. You can control its spread by the amount of liquid on the brush and by tilting the paper so that the water will do the work of moving the paint across the surface.

▷ After dampening the paper with clean water, I introduced pale colours to form blushes. While they were still damp, I applied less dilute, darker washes.

▷ For these carnations, I allowed the colours to run through the water. I gained control by having less water in the brush with each application.

△ I applied clear water to the paper first and then added almost dry Permanent Rose to the water.

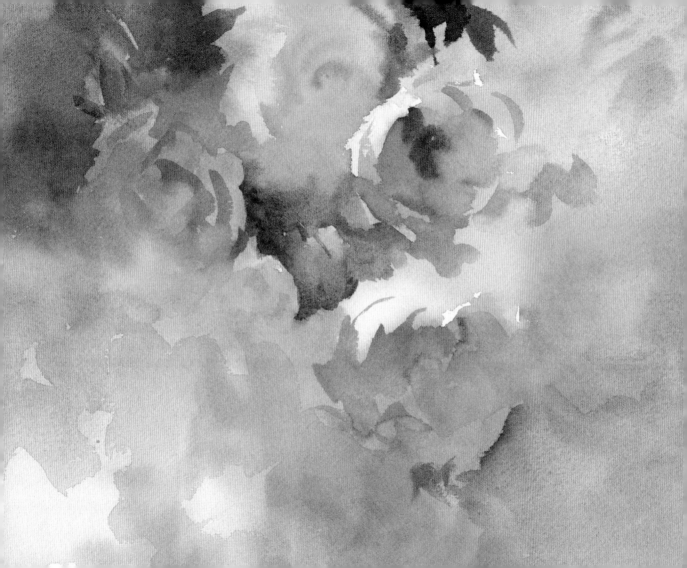

Wet-into-wet

In the method of application known as wet-into-wet, clean water or previous washes are worked into while they are still damp. This can be a recipe for disaster if it's not done correctly. A simple method of control is to use less liquid in the brush and more pigment each time you go in, thereby avoiding 'runbacks' or watermarks (which can look like cauliflowers!) and overworking.

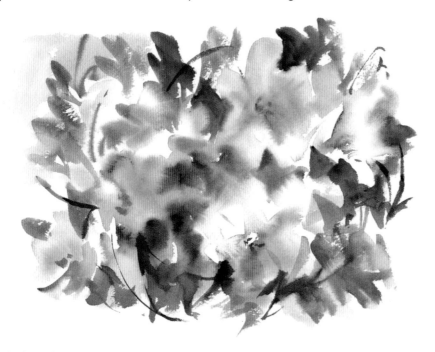

◁ I applied clean water first in indeterminate patches then added colour when the paper was still damp, with less water in the brush.

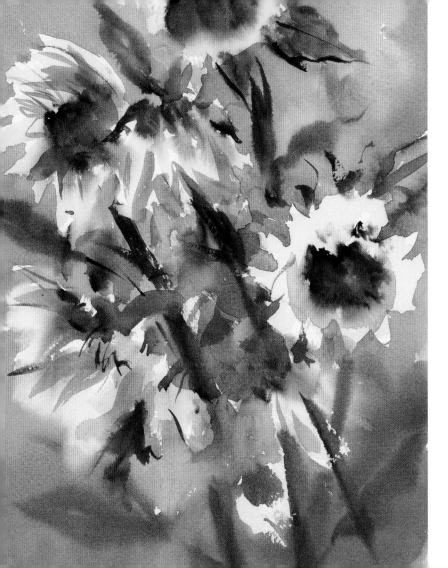

Darks on lights

It is usual to start with paler washes and then allow successive darker ones to merge wet-into-wet. This way the whole thing becomes quicker and easier to handle.

◁ **Lazy Heads**

40 × 30cm (15¾ × 12in)

Here I established the paler yellows, blues and purples first, then while they were still damp I blushed in the leaves and centres wet-into-wet. Lastly I put in the extreme dark browns and greens, dampening the areas with clear water where required.

Tone

The tonal structure of a painting – the gradations between light and shade – is vital to its message and simplicity. Often referred to as 'values', tones provide the anchor to successful picture-making. The relationship of tone and colour may appear to be complex at first sight, but when you are looking at a painting try half-closing your eyes until all the colour and detail are reduced and you will find that you can see the basic tonal structure. You will normally be able to observe at least four distinctive tones – light, dark, and two tones in between, known as half-tones.

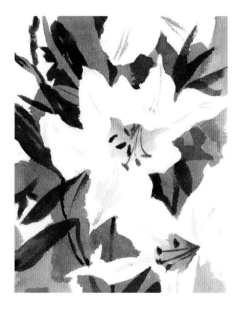

△ I placed my light half-tone shapes down first and these acted as my guide to the other tones and shapes. I then went back to the centre flower and put in the centre and the striations. I painted the negative spaces around the outside, then put in the darks.

| White paper | Light half-tone | Dark half-tone | Almost black |

△ Shown here is a tonal range from light to dark, using mixes of Lamp Black. The white is blank paper.

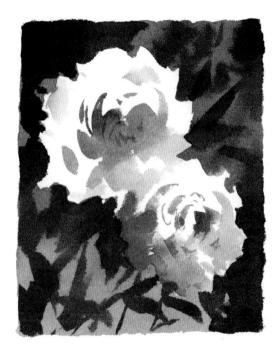

△ This time I used a sepia for a tonal layout – Burnt Sienna mixed with a small amount of Lamp Black. I mixed up my four tones again, only this time my white paper was used to describe the light hitting the two flowers.

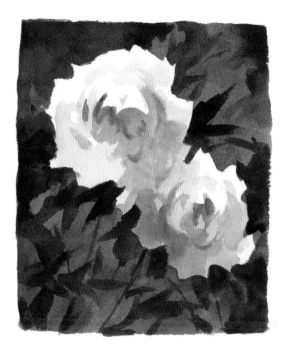

△ **Two Deep**

19.5 × 19.5cm (7½ × 7½in)

I liked my tonal sketch so much I decided to introduce colour for a finished piece. Mixing up another batch of sepia tones, I introduced small amounts of colour to them as I went along: Vermilion, Cobalt Blue, Ultramarine Blue, Violet and Lemon Yellow. This took longer than the tonal sketch but was well worth it. The colours took on a tertiary, subdued quality, giving the picture a classical effect.

Brushwork

The brush is the primary tool when painting in watercolour. It can be used in a variety of different and exciting ways and needs constant practice. Always keep a brush in your hand when painting, then it will become familiar, like an extension of your finger. Here are some tried-and-tested methods of brushwork to practise.

△ Here, quick strokes of the brush have been applied to a damp wash.

△ The dry brush technique is when you work with a brush that is only just damp so that it skips over the paper.

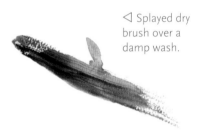

◁ Splayed dry brush over a damp wash.

◁ Pressure strokes, pushing the brush down and then lifting.

△ Two colours in the brush with applied pressure strokes.

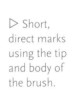

▷ Short, direct marks using the tip and body of the brush.

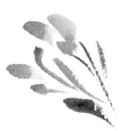

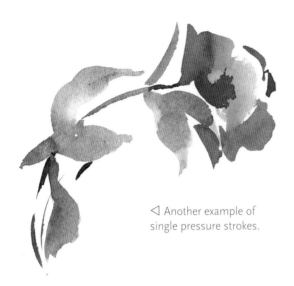

◁ Another example of single pressure strokes.

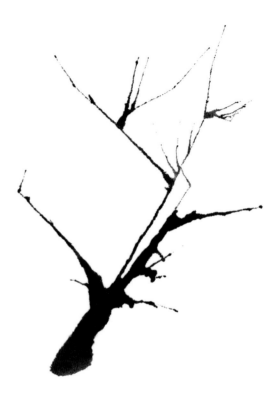

▷ Splattering with different colours is done by placing a fully loaded brush near the paper area you want to cover, then tapping the brush with your forefinger.

△ A very liquid patch of paint can be blown in slightly different directions. You can also use a straw for this.

Using bigger brushes

Here are some other useful techniques to try, this time using more liquid and a bigger brush. Let the paint puddle on the dry paper rather than spreading it out, as this will give a fresher look to the finish. Letting washes dry tests your patience but is well worth the effort.

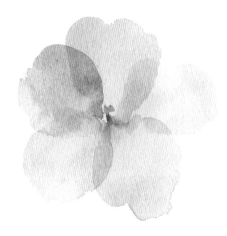

△ Working wet-on-dry, I allowed every petal to dry thoroughly before putting down the next colour, working in a clockwise motion.

△ I applied liquid darks to dry paper using a big sable brush and then blew the paint in outward directions. While it was wet I added scratch marks with my fingernail – a technique known as 'scratching out'.

Glazing

The technique of glazing is a simple one; it's really just an extra-thin colour wash, applied wet-on-dry. I use glazes for shadow effects and enhancing the depth of a watercolour.

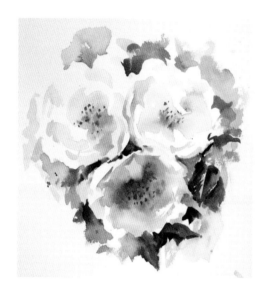

△ The original painting above had been done some time before so was perfectly dry. I then set about glazing using mixes of Ultramarine and Permanent Rose together with Indian Yellow and Ultramarine.

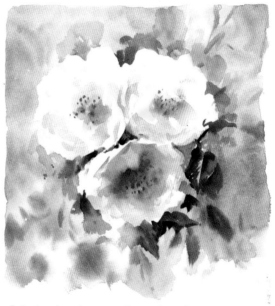

△ In the glazed version, the washes of transparent colour work their magic even in the background.

Silhouettes

A quick and simple way of understanding the profile and structure of a flower is to paint a silhouette. I use them all the time, especially in background areas, to indicate more flowers or foliage without robbing the main ones of their interest. Silhouettes do not have to be dark; they can be paler, with other colours dropped in.

△ I applied a flat wash of purple from top to bottom, following the shape of the delphinium.

△ I laid the dominant green first over the whole silhouette, then dropped in some Alizarin Crimson.

△ Here I used Vermilion for a snapdragon silhouette, varying it with Cobalt Blue.

Demonstration: Forget-me-nots

In this two-stage demonstration, the silhouette shapes of the forget-me-nots should be laid down quickly in stage 1. They should still be damp while stage 2 is completed.

Cerulean Blue

Alizarin Crimson

Ultramarine

Indian Yellow

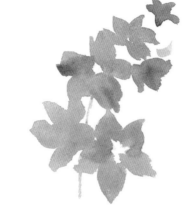

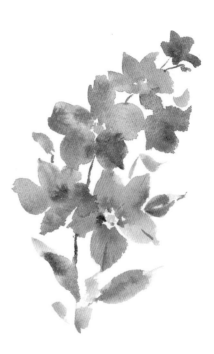

Stage 1 First, I mixed the two blues together, taking care to mix enough that I wouldn't run out while painting. For variation, I also added Alizarin Crimson at this stage to some of the blue flowers while they were still wet on the paper.

Stage 2 I placed a concentrated mix of Indian Yellow in the centres of the flowers while the first stage was still damp. Then I used mixes of Indian Yellow and Cerulean Blue for the simple foliage.

Negative spaces

The spaces between and around the flowers are just as important as the flowers themselves. These are termed 'negative spaces', as opposed to the positives of the flowers and foliage. Ensuring that your negative spaces are interesting will throw the flowers into relief, so remember to think about them as an exciting alternative rather than just background.

▷ **Apple Blossom Time**

38 × 57cm (15 × 22¼in)

Although this painting looks complex, it is very simple and consists mainly of negative shapes; very little work went into the blossom. The paler blues and darker values make the buds and blooms pop forward.

△ Here the negative dark shape reveals the flower shape in a powerful way.

△ The background space only was painted here, leaving the flower shapes to stand out ready for painting.

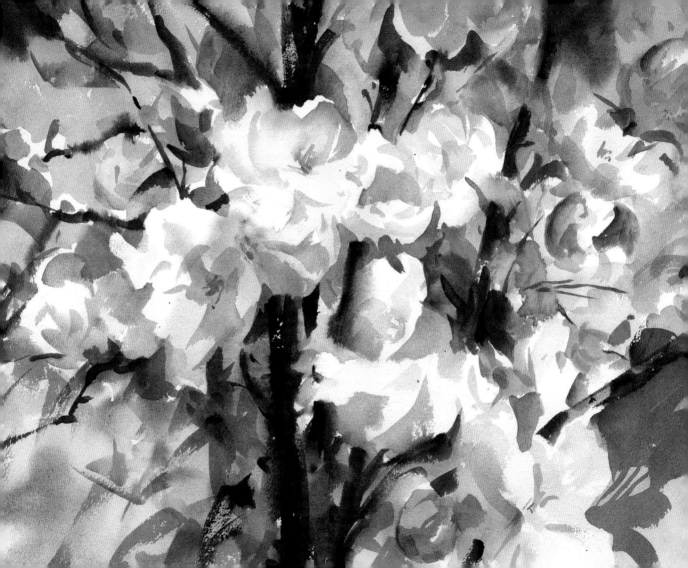

COLOUR AND TONE

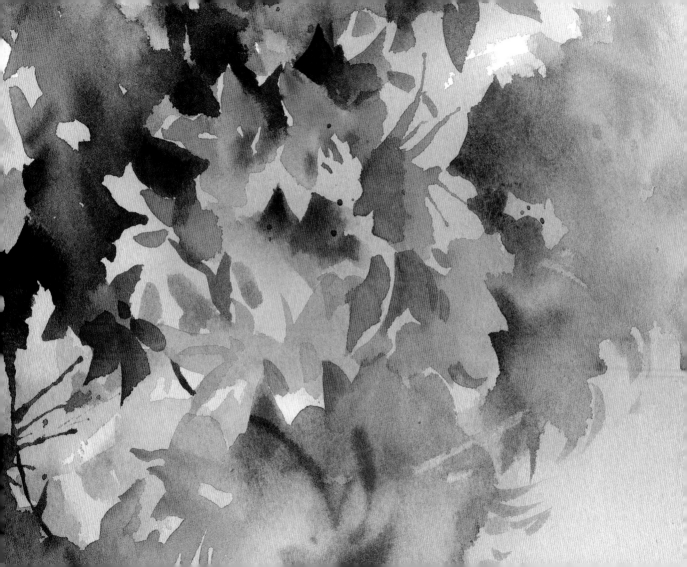

Primary colours

In painting, the primary colours are red, yellow and blue. However, there are different types of primaries depending on where they are situated in the colour circle. For instance, if a red is inclined towards purple or blue it will be known as a 'cold' red, just as a blue with a leaning towards purple is referred to as a 'warm' blue, and so on around the circle. This will help you identify what temperature of colour you are looking at and how to find it. Make a study of the colour circle here to familiarize yourself with these dispositions.

△ **Relationships**
Colours opposite each other in the circle are known as 'complementary' colours, the ones next to each other as 'harmonizing' colours, and the ones next-door-but-one to each other as 'contrasting' colours.

Primary colour combinations

Here are some sets of primary colours that work well together.
Give yourself some time to try them out and play with the mixes
before you paint your subject.

◁ Permanent
Rose, Cerulean
Blue and Raw
Sienna.

△ From left to
right: Vermilion,
Indian Yellow and
Ultramarine Blue.

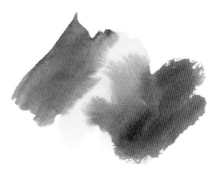

◁ Phthalo Blue,
Lemon Yellow
and Alizarin
Crimson.

Secondary colours

This term refers to colours made by mixing two primary colours together. For example, blue and yellow make green; red and yellow make orange; and blue and red, violet. Many variations of these mixes can be achieved by using one colour in a more dominant role than the other. While secondary colours can be purchased ready-made, flower painting is more exciting when you mix your own.

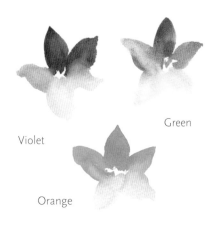

Violet

Green

Orange

△ Cerulean Blue and Indian Yellow. The colour is made by the overlap.

△ Permanent Rose glazed over a dry wash of Indian Yellow produces a natural orange.

△ Ready-made secondary colours, such as Hooker's Green, Cadmium Orange or Violet, can be extremely useful.

◁ Here Permanent Rose has been washed over Cobalt Blue to produce a violet.

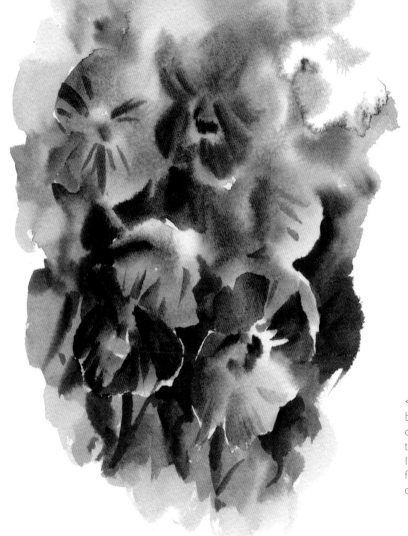

△ **Detail** The dominant violet, when dry, has been glazed across with Cobalt Blue for a dramatic colour change.

◁ A combination of secondary colours has been used here to create this small vignette of purple pansies – a ready-made violet together with variations of Cobalt Blue and Indian Yellow, with Ultramarine Blue for the foliage. The orange centres are an uneven mix of Permanent Rose and Indian Yellow.

Tertiary colours

When a primary is mixed with a secondary colour the result is called a tertiary colour. Tertiaries are earthy or greyish in appearance and are often referred to as the 'neutral' colours. These colours appear in nature all the time. For example a red rose will have its opposite or complementary colour in its darker leaves and stems, thereby creating tertiary mixes. Tertiary colours provide a key to luminous flower paintings.

Violet with orange and yellow.

Blue and violet mixed with yellow.

Violet and green infused with yellow.

△ **Complementary mixes** Alizarin Crimson and a mixed green; Cobalt Blue and a mixed orange from Indian Yellow and Vermilion.

▷ **White Camellias**
26.5 × 34cm (10¾ × 13¼in)
There are many tertiary mixes used here, from pale to dark. I find these colours endlessly fascinating, and they are excellent for natural-looking flower paintings.

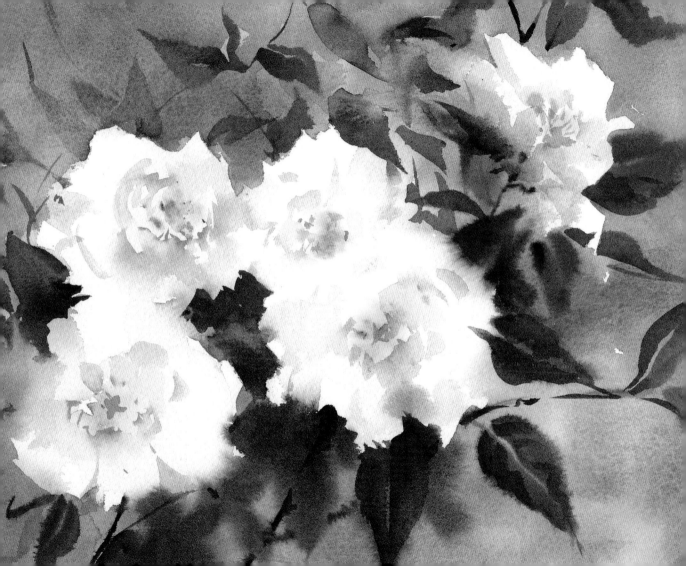

Demonstration: Bearded Irises

This demonstration uses all three sets of colours: primary, secondary and tertiary.

Stage 1 I wetted the paper with clean water, then established the main shapes using primary combinations of Permanent Rose, Cobalt Blue and Lemon Yellow.

Stage 2 When the first stage was dry, I applied secondary colours of Permanent Violet, a green mix of Lemon Yellow and Cerulean Blue, and orange made from Lemon Yellow and Permanent Rose.

Stage 3 Next I worked on establishing the shadow shapes inside the flowers, using pale mixes of Permanent Violet and Permanent Rose. Then I applied thin washes of Lemon Yellow and Cerulean Blue to the negative shapes.

Stage 4 I worked up the negative spaces around the flowers and foreground stems, introducing tertiary colours for darker tones.

▷ **Stage 5**
26.5 × 26cm (10¾ × 10in) I added in some detailed striations and then further adjusted the darker tones in the shadow areas to complete the painting.

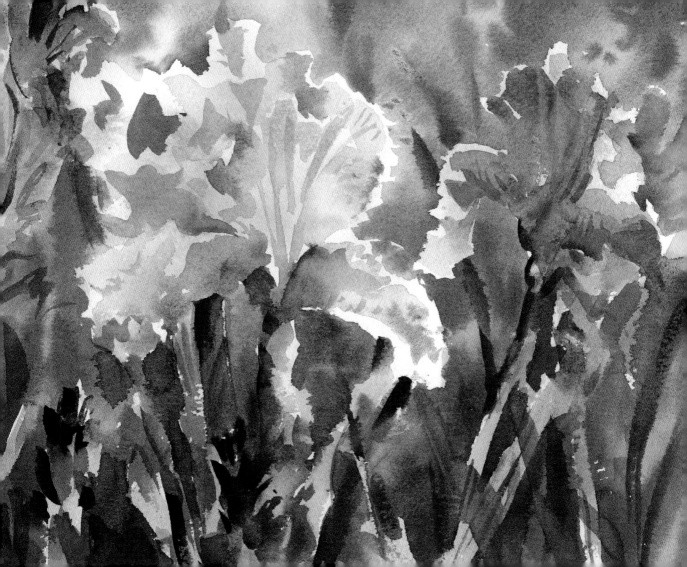

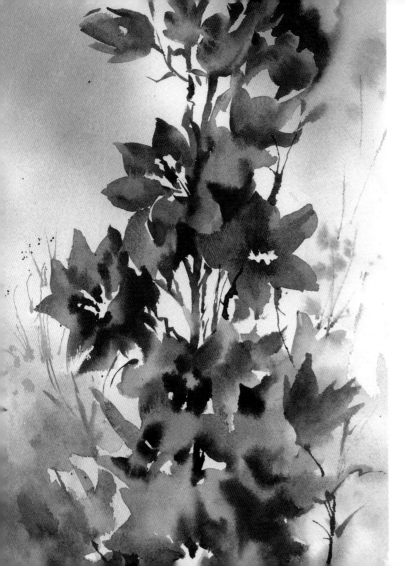

◁ **Delphiniums**

32 × 24.5cm (12½ × 9½in)

Mixes of Cobalt Blue, Cerulean Blue and Permanent Violet were allowed to run freely through the flowers in this painting. Granulation occurred when the blue pigments ran into the transparent ones.

▷ **Rose Cup**

25 × 34.5cm (9¾ × 13½in)

There is plenty of granulation in this painting, with the Cerulean Blue in the background and the slightly gritty nature of Alizarin Crimson in the darker parts of the roses.

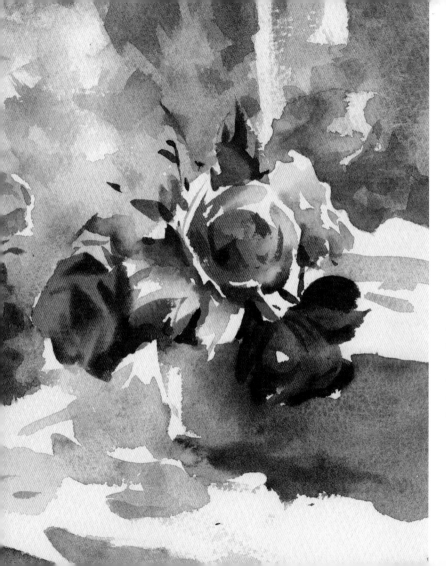

The properties of watercolour

Watercolours are manufactured from finely ground grains of pigment mixed with a binder of transparent gum arabic. Each colour contains a property of its own. Some are fully transparent, some semi-opaque; some are granular, or gritty. For example, Ultramarine Blue is very transparent and at the same time granular, whereas Permanent Rose is transparent and lightfast, or non-fading. Experiment with these properties and use them to bring further subtlety to your flower paintings.

Colour temperature

Colours are described as having a temperature – hot, cold or somewhere in between. This always depends on the strength of the colour being used, and those that surround it – relationships between colours will always affect the viewer's response. What we perceive as hot and cold in terms of colour simply reflects what we know from life: fire and the sun are hot reds, oranges and yellows, while ice and snow have tones of blue. Within each colour there are hot and cold variants.

△ **Basic colour thermometer** Clockwise from top: Vermilion (hot), orange (warm), Lemon Yellow (cool), Sap Green (warm), Turquoise (cold), Cobalt Blue (warm), Violet (cool), Alizarin Crimson (cold).

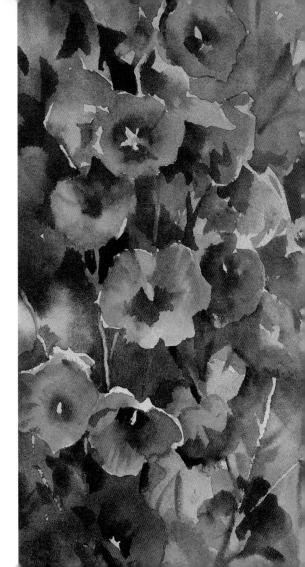

▷ **Hollyhocks**
30 × 23.5cm (12 × 9¼in)
Here I've used a backwash of colours to start, flowing from Cobalt Blue and Cerulean Blue through Permanent Violet and then Lemon Yellow to Vermilion, so cold gave way gradually to warm. This wash guided my instincts with the flowers and the foliage.

Practising colour temperature

Here are some practice pieces in colour temperature for you to try. I worked these colours down the page from top to bottom, allowing them to merge as I went along.

Cerulean Blue

Cobalt Blue

Violet

Alizarin Crimson

Vermilion

Orange mix:
Indian Yellow and
Vermilion

Indian Yellow

Lemon Yellow

Green mix:
Lemon Yellow and
Cerulean Blue

◁ Here, I mixed indeterminate patches on the paper. Top to bottom, left to right: Cobalt Blue, Cerulean Blue, Violet, orange mix (Indian Yellow and Vermilion), Lemon Yellow.

◁ In this simple landscape, colours are merged wet-into-wet to create recession. The colder colours recede and the warmer ones advance.

More colour, more feeling

Our mood is very much affected by the colour of our surroundings, and art exerts the same effect. Controlling the mood of your work is paramount, especially with flower painting. The simple inclusion of a certain colour, or strength of colour, affects the overall design and the viewer's emotional response.

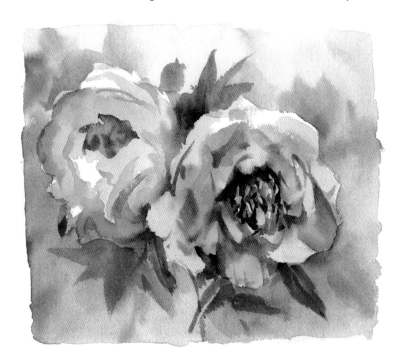

◁ **Peony Pair**

17.5 × 20cm (6¾ × 8in)

I painted the peonies first, then the darker leaves. Once they were dry, I concentrated on colour washing a background to add a sense of space. Although there are only two flower heads, varying in colour, there are a lot more by suggestion. The crisp whites make the blooms stand forward.

◁ In this simple colour sketch the pale washes and white paper seem to recede more. A happy accident of crimson on the left-hand side makes this one worth keeping.

△ This accidental crimson runback forms a wonderful inclusion.

Subtle colour

Colours vary a great deal in nature – in fact from one flower to another there can be infinite colour nuances and strengths. A white rose, say, is anything but white. A pink tulip may have its dominant colour for all to see, but if you take a closer look you will find subtle transitions.

▷ **Church Roses**
37 × 56cm (14½ × 22in)
Lemon Yellow and Indian Yellow have been used here to create the basic colour of the flowers. I then varied this by adding a mix of Cobalt Blue and Violet to form the cooler shadows on the roses and the background.

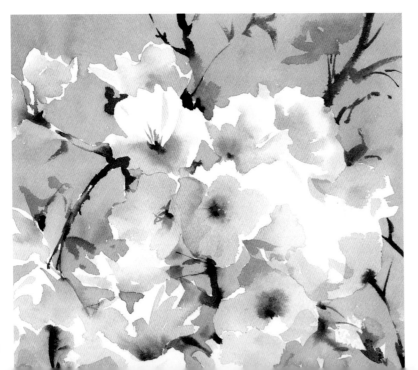

◁ **Cherry Blossom**
23.5 × 28cm (9¼ × 11in)
All the pale colours in the shadow regions and the darker connecting branches were painted first onto the white paper. The Cerulean Blue background was added last in one large wash, varied only slightly in places, to wrap around the flowers and throw them into relief. I added a few leaf shapes after the Cerulean Blue was dry.

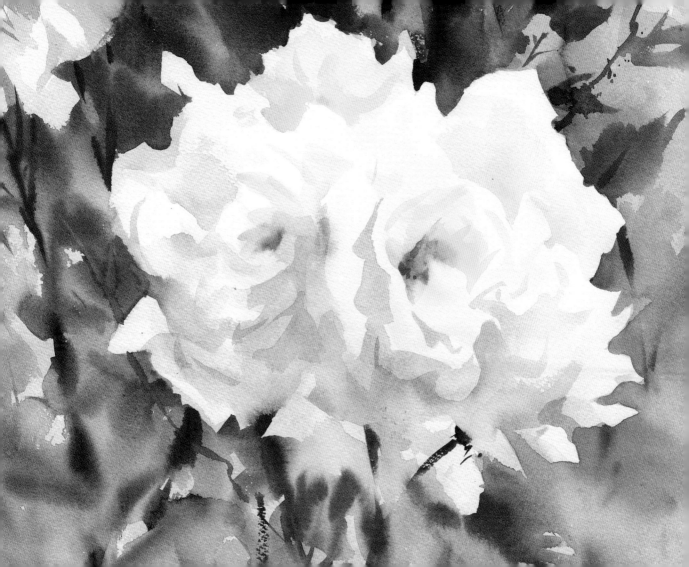

Demonstration: Sunlit Daisies

The concept of tonality gives you the whole palette of colours and values to play with. Adding darker tones in watercolour can be scary, but using the full range of tones will boost the dramatic effect of your paintings. Following this two-stage demonstration will test your tonal abilities to date.

Stage 1 Starting with the flower centres, I washed in a light half-tone mix of Indian Yellow and Burnt Sienna. I fanned out the petals and their shadows, using Cobalt Blue and Violet, then put in the dark stalks with mixes of Cerulean Blue and Burnt Sienna.

Stage 2 I let the first stage dry thoroughly, then mixed up two separate tones of a pale tertiary green using Cerulean Blue and Indian Yellow with a touch of Burnt Sienna. I washed the paler mix of greens in the background, around the outsides of the flowers to trap their shapes, then used the darker green mix to show the leaves and stems.

▷ **Great White Orientals**
22 × 18.5cm (8½ × 7¼in)
I painted the centres of the flowers first to establish their position on the paper with mixes of Ultramarine Blue, Permanent Rose and small amounts of Cadmium Orange. Then came the shadow areas of Ultramarine Blue and Permanent Rose to determine the petals. Lastly the two large dark areas behind the flowers were made from concentrated mixes of Ultramarine Blue, Cerulean Blue, Vermilion, Permanent Violet, Burnt Umber and Indian Yellow.

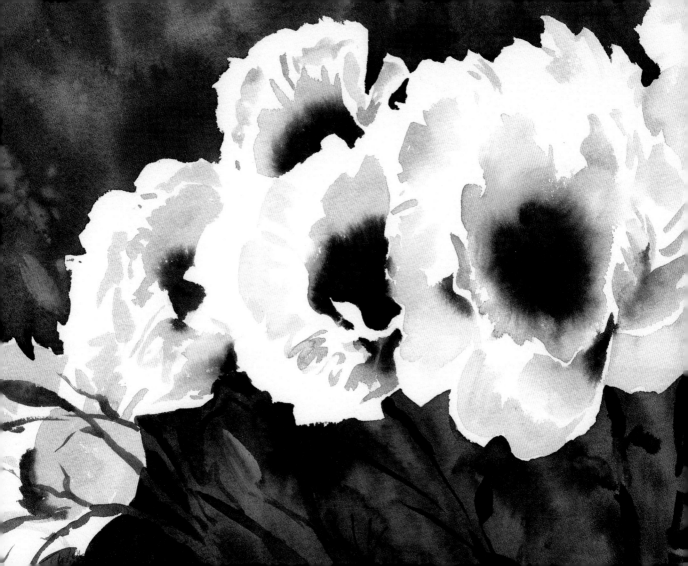

Gradation

To give the appearance of three-dimensional form on the flat surface of your paper, you will need to use gradation – dark to light sequences. There are three main ways of doing this in watercolour, all useful in their own ways: applying clear water to the paper and then brushing in darker paint; applying dark paint directly to the paper and then adding water to allow the paint to drift; or by putting paint on the paper and then using a damp brush with pressure for finer control. For smoother transitions, the last option is my preference.

△ **Gradation 1**
Wet the paper first and then add Cobalt Blue at full strength. Encourage the flow by tilting the paper at the relevant angle.

△ **Gradation 2**
Put full-strength Burnt Sienna down and then use clear water to gradate the colour. Tip the paper at an angle to encourage smoother transition.

△ **Gradation 3**
Lay down Permanent Rose in a single brushmark and then press a damp clean brush into the edge once. Let the water do the rest.

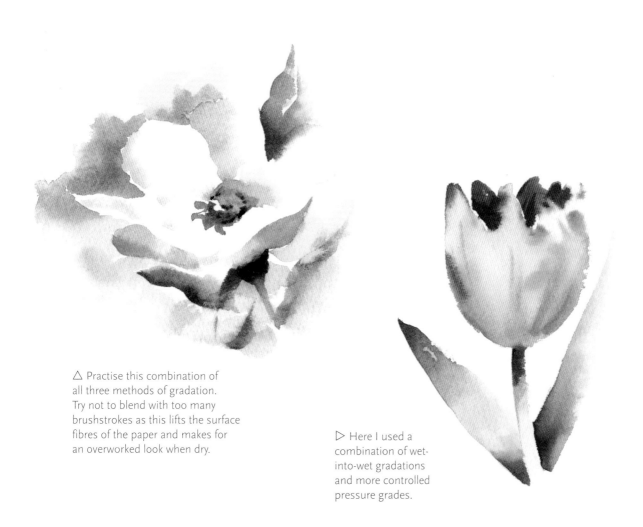

△ Practise this combination of all three methods of gradation. Try not to blend with too many brushstrokes as this lifts the surface fibres of the paper and makes for an overworked look when dry.

▷ Here I used a combination of wet-into-wet gradations and more controlled pressure grades.

CHAPTER 5

KEEPING
IT SIMPLE

Large before small

Always tackle large areas first when you start a watercolour, putting as much down in the first wash as possible. Try not to allow the smaller areas to distract you at this stage. Speed with accuracy is the motto when starting out. Below are examples of first washes.

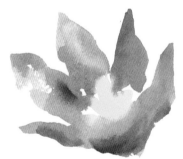

▽ Here I worked urgently, putting down the main petals with pressure strokes of the brush and then adding the yellow shape in the centre.

△ This was done in one wash, mixing colours as I saw them, directly on the paper. I allowed them to mix freely while controlling the overall shape.

△ This time I left the centre of the clematis flower blank, to be completed when dry.

Varying tones

I put the bright colours down first because they give impact and freshness. I varied the tones in this first wash by adding more concentrated colour while the painting was still wet. This meant working rapidly.

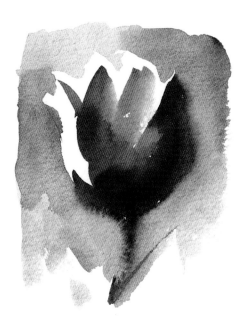

△ I put down washes of Violet and Permanent Rose first and then varied them with more concentrated mixes at the same time. Next I wrapped the green negative space around the flower to capture the light.

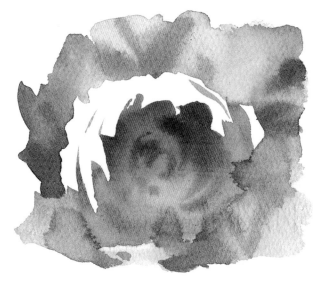

△ After laying in the main central area first, I brought a pale wash around the outside of the flower to quickly trap the light. I went back to the centre immediately to include darker tones of red and then used these same dark tones in the background area.

The single brushstroke

In watercolour painting, the power of the single brushstroke reigns supreme over any inclination to dabble or scrub with a brush. It is also the signature of the artist and shows their confidence and ability. However, painting with confidence requires practice, so make single brushmarks until they become fluid and natural to you – they should not look laboured or mechanical. The secret of watercolour brushwork is to use as few strokes as possible; every one of them should be essential.

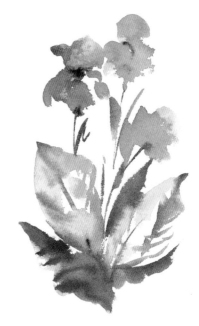

▷ This is an example of single pressure strokes using the tip of the brush as well as the body. I've also used some wet-into-wet variations for the leaves.

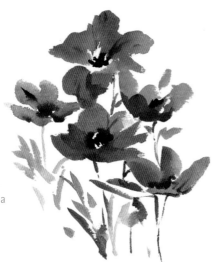

▷ All the brushmarks on this one have been made with single strokes – a collective group of marks.

▷ **Cornflowers**

23.5 × 32.5cm (9¼ × 12¾in)

Here I put the background in first, wet-into-wet, changing colour as I worked from top to bottom, left to right. The flowers are painted with small stabs using a No. 8 round brush.

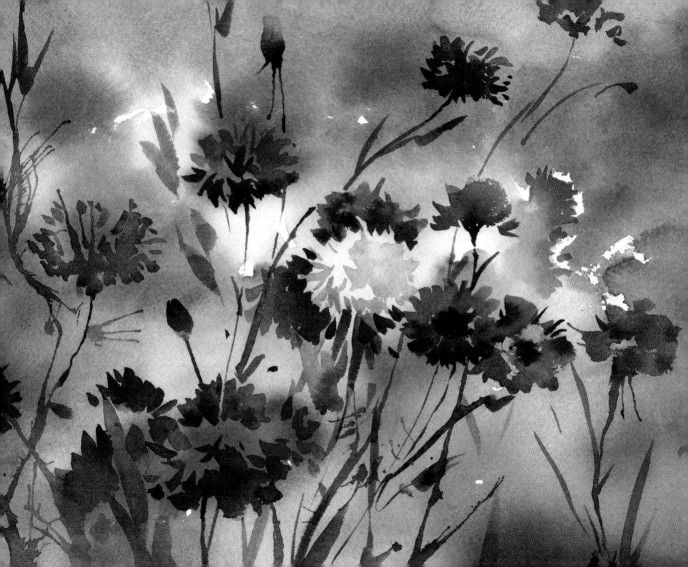

Maintaining the freshness

In order to keep the freshness in your washes, use plenty of water as well as plenty of colour for the large areas, especially in the first stages of a painting. This will bring more transparency to your finished result when dry. You will always be wanting to add more things rather than simplify. Try to resist this temptation and consider your next move in advance. The great watercolour artist John Singer Sargent once said that watercolour is 'making the best of an emergency'.

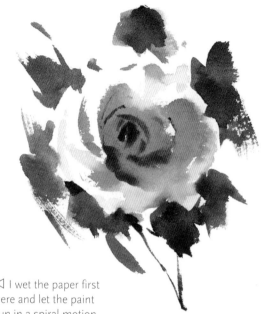

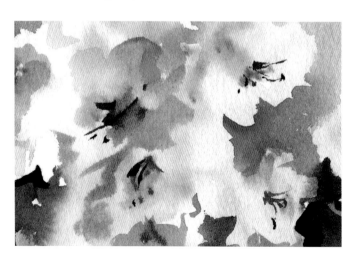

◁ I wet the paper first here and let the paint run in a spiral motion guided by the brush. I added small dark brown dots and dashes last.

△ Considered brushwork means thinking first and then acting. In this I limited my ambitions to just shadow shapes and dark foliage.

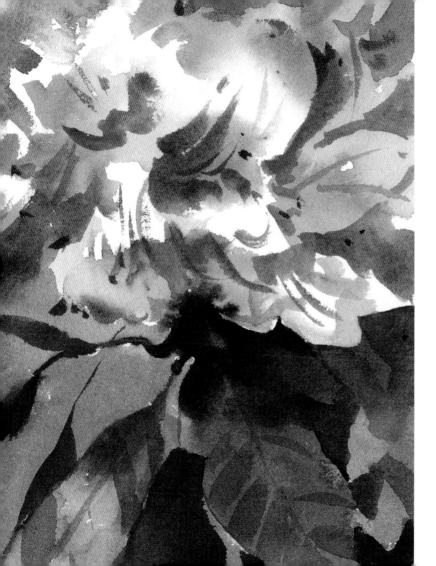

◁ **Rhododendrons**

23 × 14cm (9 × 5½in)

This required the freshness of a wet-into-wet mix on the paper of varying strengths of Permanent Rose. The big leaves were flat washes with single brushstroke markings. Lastly, when the rhododendron was dry, I laid my flat blue wash in the background.

Demonstration: Spring Tulips

There is nothing like the freshness of spring colours. To capture these you will need to keep your washes simple and applications immediate. Remember to mix enough wash colour to cover the intended area, and limit your actions to just three wash layers. I have used each stage here as an example of those layers.

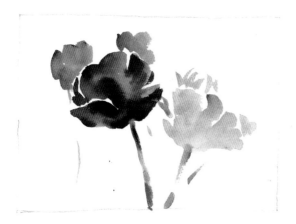

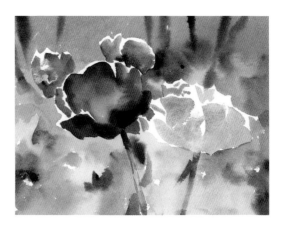

Stage 1 Firstly, I established where the main flowers were going to be by using concentrated washes of Permanent Violet and Permanent Rose. The white tulip has paler shadows of Cobalt Blue and Indian Yellow. I added some stems into the foreground using the same two colours.

Stage 2 The whole background was done in this stage, starting at the top left with a concentrated wash of Cobalt Blue and working around the flowers, leaving some white paper around their top edges. Then I added Indian Yellow and Cobalt Blue, mixing the two colours on the paper. Next, I added some Permanent Violet, wet-into-wet, to the foreground colours. The darker Cobalt Blues were put in last, using less liquid and more pigment in the brush.

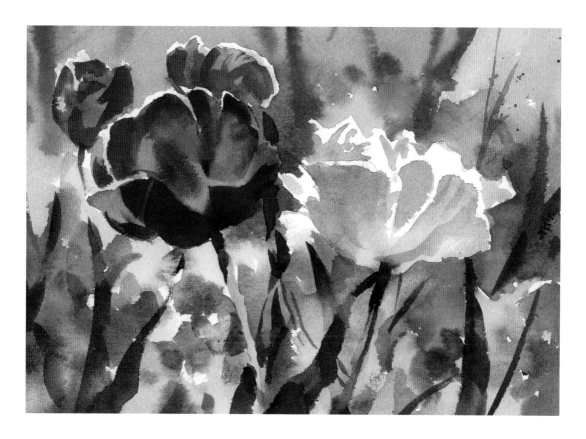

Stage 3 Spring Tulips *17 × 24.5cm (6½ × 9½in)* Further enhancements were added here using darker mixes of the same colours as before, over stages 1 and 2 when dry. Cobalt Blue and Indian Yellow mixes were used for the foreground leaves, and concentrated Permanent Violet for the deeper shadows on the flowers.

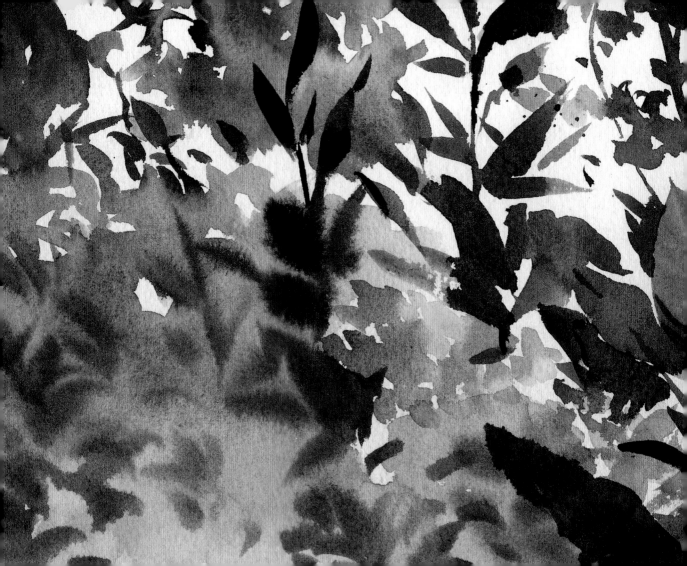

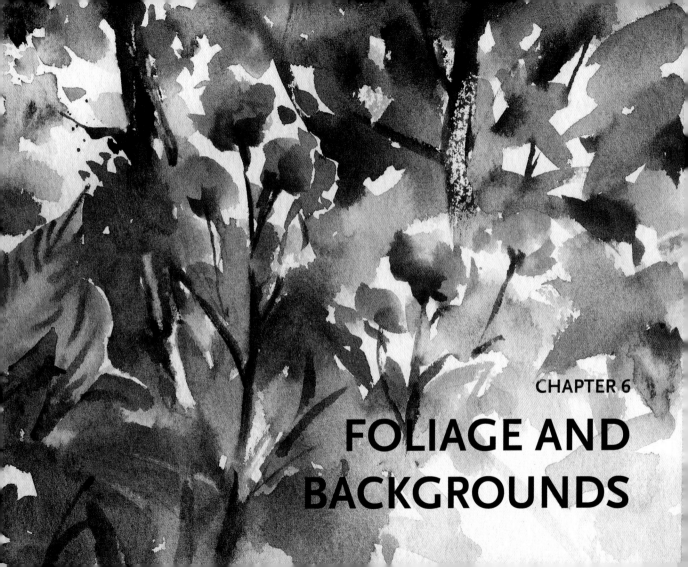

CHAPTER 6

FOLIAGE AND
BACKGROUNDS

Leaves and stems

In painting as in life, flowers need the support of leaves and stems. Usually, flowers are seen as light objects against a darker backdrop of foliage, but this is not always the case. Observation is all-important here for paintings that look true to life. The same methods of paint application that you have practised with flowers also apply to backgrounds.

△ The colour of the flower often appears in its foliage. Here a green base has the red of the flower combined in it. I lifted out highlights using a thirsty brush.

△ For this frond, I placed single strokes of the brush on either side of a central stem, using Ultramarine Blue and Indian Yellow.

△ I put down the shape of an autumn leaf in Yellow Ochre first, carefully leaving the paper white for the central spine, then dropped in more colours while the wash was damp.

Massed foliage

Massed areas of foliage are painted as one unit. The practice of silhouette painting (see page 46) will come in useful here. It is a chance to be very creative, not only with the colours that you use, but also with the diversity of techniques that you play with. I like to let my brush wander a bit more in these collectives, exploring rhythms and directions.

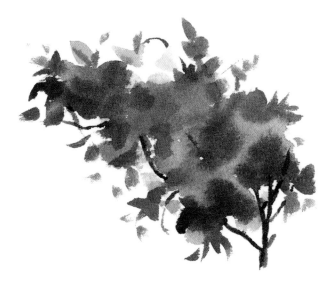

▷ A concentrated mix of Burnt Sienna and Violet conveys this foliage.

△ I put down clear water over the central area here and then allowed colours to bleed into it. The breakaway leaves and branches were added last.

Creating foliage

Beautiful brushstrokes and colours make for exciting and inventive watercolours. With ingenuity and a willingness to explore, you can transform passages that could be regarded as the less interesting parts of a painting into creative opportunities instead. Try this little exercise for practice.

Stage 1 Wet the paper using clear water. Put in a concentrated mix of Cobalt Blue and then Indian Yellow. Let the colours swirl together.

Stage 2 While the mix is still wet, add a darker combination of Cobalt Blue and Vermilion and allow it to run.

Stage 3 Drop in very concentrated Vermilion and extend the outside edge with straying leaves and flowers.

Branches

Branches are not just additional objects in a floral painting; they are the main support mechanisms in conveying the structure of a piece. They give a sense of direction and weave in and out of flowers and foliage.

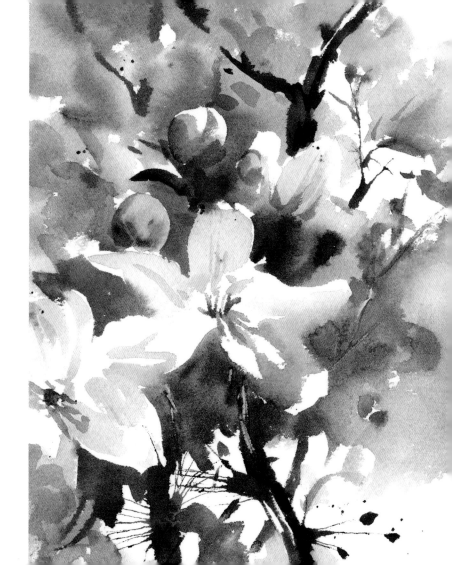

▷ This quick piece shows that the branches are the main underpinning of the sketch, directing the eye of the viewer. Using Ultramarine Blue in combination with Burnt Umber to make the richest of darks, I blew the paint on either side of the branches and scraped back to the white of the paper using my fingernail.

Using the white paper

To represent more light in watercolour, or to depict white flowers, the paper itself is often reserved while painting, which can give a sparkling result. You will rarely need white paint if you plan this in advance. You may require pencil guidelines to show you where these areas are, though I find that painting shadow areas first allows me to dispense with lines. Observe the tones of your shadows as accurately as you can, as this will give a more realistic result. They are normally half-tones, but may on occasion be a little darker here and there.

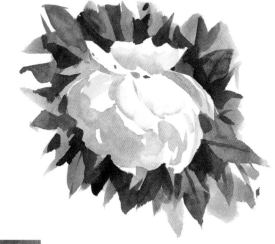

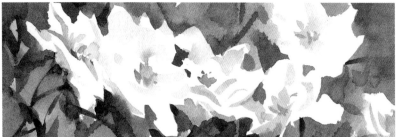

△ I started with placing the yellow centres on the flowers first and with them the pale shadows on the flowers. The white paper was then reserved by the negative or background washes.

△ This little vignette started with the greyish shadow tone underneath the flower and around its top petals. This completed, I then had a fix on the surrounding foliage, allowing me to dispense with line to demarcate the white space.

▷ I made extensive use of the white paper here by starting at the centres of the flowers first and following the shadow formations.

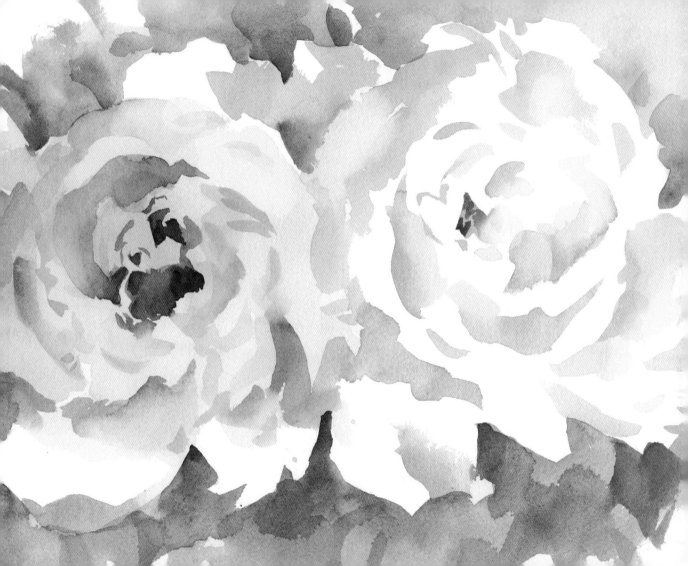

Demonstration: White Peony

Using the white of the paper requires a certain amount of patience and looking ahead. Looking for the variety of tones as they dance across the surface of flowers and leaves can be confusing, but remember there will always be a light side and a shady side and consider the angle of light from the beginning. Stand back from the painting now and then to visualize its finish.

▷ **Stage 4**
White Peony 24.5 × 31cm (9½ × 12¼in)
Strengthen the darkest areas using concentrated Permanent Violet and a bluish green made from a small amount of Lemon Yellow mixed with Cobalt Blue. These last washes further enhance the white of the paper reserved from stage 1.

Stage 1 Wet the paper with clear water and when damp work the centre shapes of the flower with Vermilion. Establish the shadow shapes using pale washes of Permanent Violet and Cobalt Blue, then work outwards towards the edges. Use pale washes of Lemon Yellow and Cobalt Blue for the background. The white of the paper can now clearly be seen.

Stage 2 Go back to the centre of the flower and develop the darker parts with Alizarin Crimson. Move to the background and start to add stronger mixes of Lemon Yellow and Cobalt Blue in the negative spaces to achieve more accuracy with the outside edge of the flower.

Stage 3 Keep developing the negative darks all round the flower so that its appearance becomes whiter. Add in the other elements such as the bud and leaves.

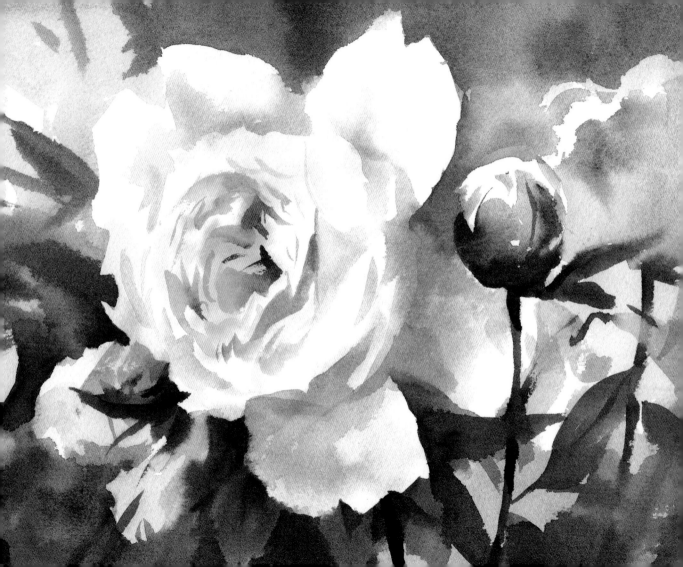

Directing the eye

You can use brushmarks to direct the viewer's eye around a painting. A powerful tool in the language of art, it appears in nature in the form of striations and markings on flowers and leaves or the texture of tree bark and grasses. How the brush is employed will convey movement, emotions, activity and texture. This practice is especially handy when painting the markings on flowers.

△ The brushmarks are in several directions to create interest here: semi-circular movements in single strokes; red markings fanning outwards, applied wet-into-wet; dots and blobs at the end of the flowers; and some ornate curls. All of this directional movement keeps the viewer's eye engaged.

△ **Circular motion**
– directs the eye inwards.

△ **Curved brushstrokes**
– directs from base to tip.

△ **Ornate curves**
– more decorative movement.

△ **S-shape**
– gentle curved movement.

△ The whole group moves outwards, fan-like, from the base and some striations on the flowers show the curves of their petals.

▷ This simple sketch uses upright sweeps with a large round brush. I put in the backwash first, using Cobalt Blue and Yellow Ochre. The gentle angles of the grasses convey the sense of the breeze. Some more active angles indicate cast shadows.

CHAPTER 7

ACHIEVING
ARTISTRY

Edges

The well-seasoned watercolourist will know that these edges are not accidental effects, and that practice with them will achieve greater artistry and expression. There are three main types of edge in watercolour: the hard, the soft and the broken edge. Of course you can use them in combination with each other and have endless fun choosing what type of edge should go where. Wet-into-wet techniques largely produce softer edges, while wet-on-dry gives harder ones. Dragging a half-filled brush across the paper should achieve a broken edge. You will need to put in some practice to be able to control edges in this manner.

▷ **Rose Tumble**
28.5 × 37.5cm (11¼ × 14¾in)
This diagonal design contains mostly soft and hard edges. The paper was kept wet all the way through. When edges began to dry I softened them using a damp brush.

▽ I kept the paper damp all the way through painting this. I controlled the flow of paint in the brush as it dried to achieve my desired edges.

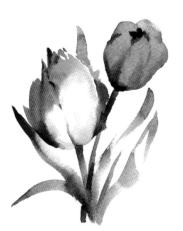

◁ All types of edge appear here: the dark pink edge as it moves into the pale yellow was softened using a damp brush, while the purple tulip has a hard outer edge and internal wet-into-wet darks.

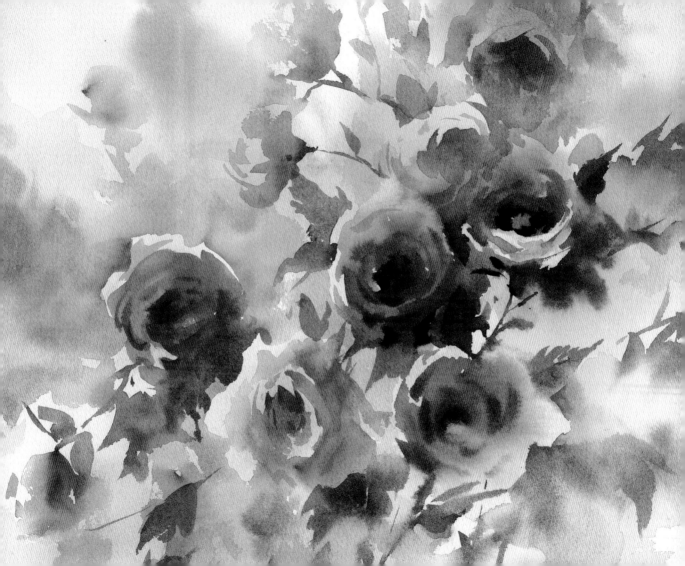

Lost and found

Sometimes you will want edges to disappear; for instance, if two colours meet that have the same tone, you have the opportunity to lose that edge, so sharp edges do not have to dominate your painting. Shadow areas often provide opportunities for lost-and-found choices, and this will in turn allow the viewer's eye to wander between background and object unhindered by abrupt edges and outlines.

▷ **Flower Bouquet**

21 × 28.5cm (8¼ × 11¼in)

I had fun with this quick painting, working wet-into-wet and then deciding on the types of edges I wanted. The shapes and colours took on a more abstract feel rather than a traditional effect. I kept the paint very concentrated and used a big brush with plenty of water.

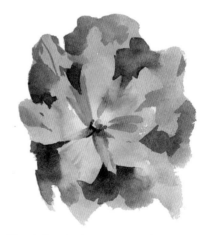

Stage 1 The colours for the opening wash were Permanent Rose, Cobalt Blue and Indian Yellow. This was wet-into-wet where all edges are kept soft or blurred.

Stage 2 The darker shadows gave me the opportunity to find edges, but I did not show them all the way around the petals – some lost or blurred edges were allowed to remain.

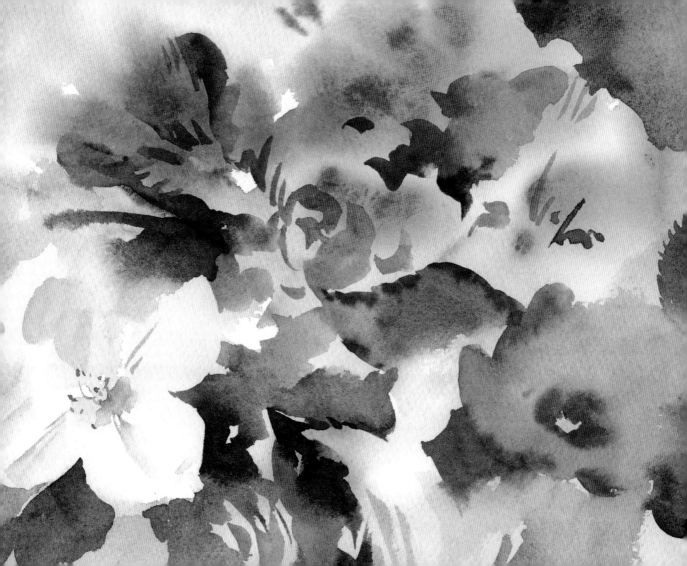

Selecting the essentials

In the interests of simplicity and effectiveness, what you put in is less important than what you leave out. A painting should have a life if its own rather than just presenting a copy of the facts. Paint what you see, say it the way you want to – if it feels right it usually is right. Your personal selection is all that counts in your art.

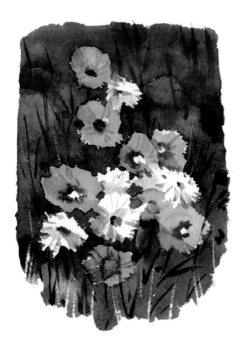

◁ I was taken by the orange and dark blue here. In this sketch, no bigger than a postcard, I chose to have soft-edged darks and hard-edged lights.

▷ Small changes in colour were important here. I tinted the violet thistle heads with Permanent Rose and the leaves and dark tones with Alizarin Crimson.

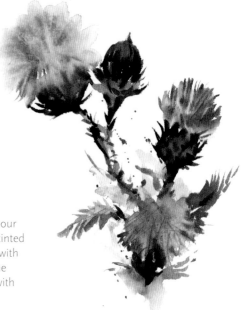

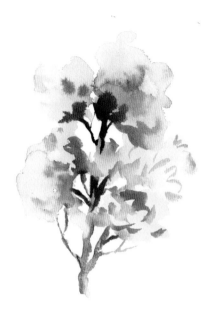

△ Working with a sense of urgency made it easier to translate the rather complex flowers of cheiranthus. I ran Indian Yellow and Yellow Ochre into a pale blue wash of Cerulean Blue.

▷ The drama of the rich dark colours in the background was the inspiration here, so I kept the flowers as simple as possible using mostly the white of the paper.

CHAPTER 8

PUTTING IT
ALL TOGETHER

Following your ideas

Paintings of flowers in watercolour do not have to be complicated or busy, nor should they be replicas of photographs or facsimiles of reality. Keep your ideas and your execution simple. Remember that the medium is attractive in itself – the way the colours overlap and naturally run together across the paper is enough for the viewer to take delight in. Painting is not a labour-intensive task, rather you should have fun and let the nature of the medium guide you.

Visual metaphors

When you look at an object or a scene you may be reminded of something else apparently unrelated – for instance, a poppy head may remind you of a cup or saucer in its shape, or a lily might resemble a trumpet. These visual metaphors are great aids to your memory and often reveal the underlying essence of the subject. Painting itself is a metaphor – it is like the thing but is not the thing.

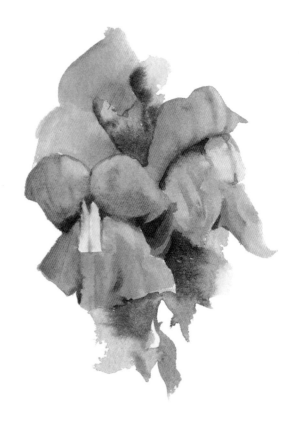

△ Snapdragons are so named because they are thought to resemble a dragon's face.

Follow your emotional reaction to your subject and work with that rather than analysing the materiality of the subject too much. Let the brush wander around the painting – don't stay in any area for too long for fear of overworking.

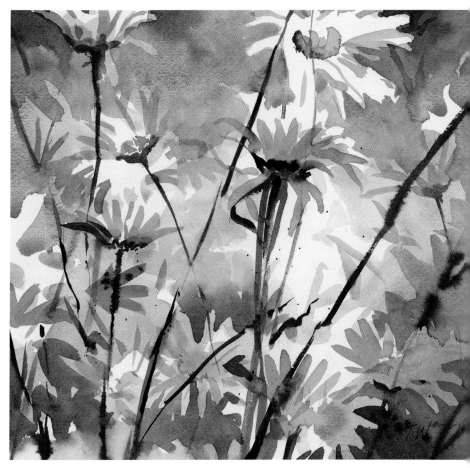

▷ I began this painting in an off-centre position and then worked outwards to my square format, allowing my brush to wander just slightly ahead of me.

Gaining confidence

Experience, practice and experimentation ultimately lead to skill, and flowers have such varied and interesting forms that there should never be a dull moment when painting them. The play of light and the captured moment will provide you with endless interest.

▷ The way the light hits the flower here, from above and from the left-hand side, gives the viewer a fleeting impression of the moment.

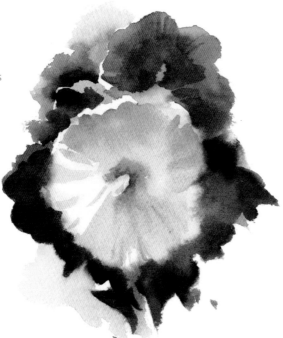

▷ **Giants**

22 × 33cm (8½ × 13in)

Slightly larger-than-life forms have been created here by taking a child's-eye view from below these towering hollyhocks. Capturing the moment, I painted the effect of the afternoon sun on the petals. The variety of sizes and colours conveys a sense of movement.

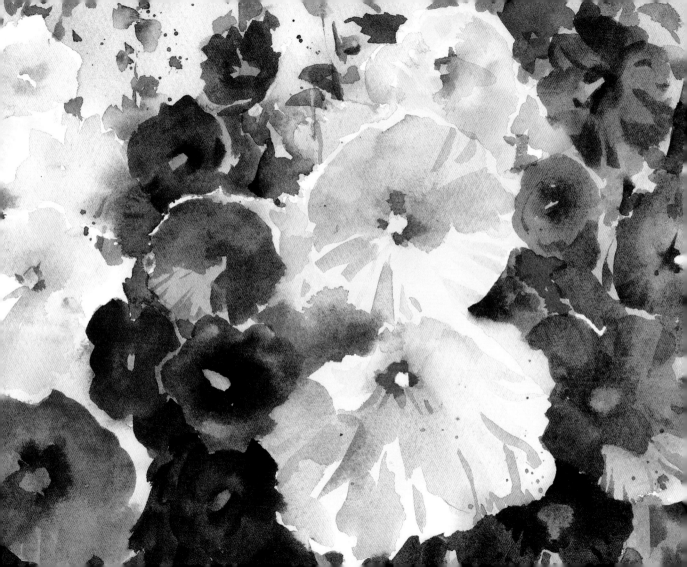

When is it finished?

There is no defined look to a watercolour. If you like what you see in the first few brushstrokes, consider finishing earlier than you expected – in fact I always say to my students in watercolour, 'Stop before you think you've finished.' After three or four layered washes a watercolour can become a bit muddy in parts. When I was an art student I asked my tutor 'How many washes can I do?' His reply was 'As many as you like but if you haven't got it in three then it's in the bin.' This is not a bad rule of thumb! Above all, do not fiddle; it just lifts fibres from the paper and your watercolour will lose its freshness.

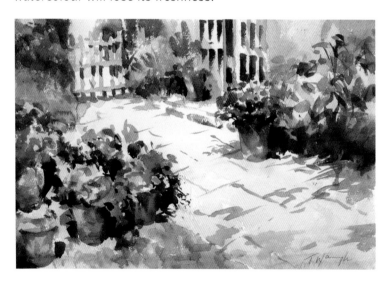

◁ This watercolour of my old studio took about two hours to do, but most of the time was spent waiting for washes to dry.

▷ **Sun Seekers**

34 × 45cm (13¼ × 17¾in)

I love to paint sunflowers with their golden colours, rounded dark brown seedheads and flamboyant leaves and stems. Most of this painting was done in the first wash after wetting the paper.

Summing up

Having conceived the desire to paint flowers in watercolour, you should be fired up with inspiration after having read this book! It is my hope that you will use it often, dipping in and out of it as the need arises. I have covered the necessary basics as regards watercolour practice and included some advice and handy hints that would only come with experience. So it's time for me to pass the brush on to you. But before I do I will leave you with this wonderful quote from the composer Gian Carlo Menotti: 'Art is the unceasing effort to compete with the beauty of flowers and never succeeding.'

▷ **Constant Companions**
35.5 × 51cm (13¾ × 20in)
This larger watercolour is my way of celebrating my love of the rose – indeed, all roses. They have been a constant source of learning and inspiration to me and my painting through the years.

Index

References to illustrations are in italics.